바람소리 그리고 흔적

강운
Kang Un

HEXAGON
WWW.HEXAGONBOOK.COM

Table of Contents

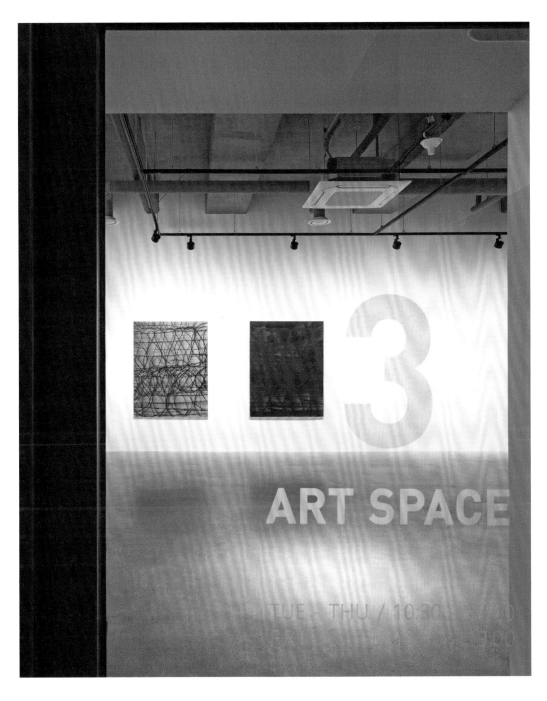

2019. 11. 1 (금) – 11. 30 (토)
ART SPACE 3

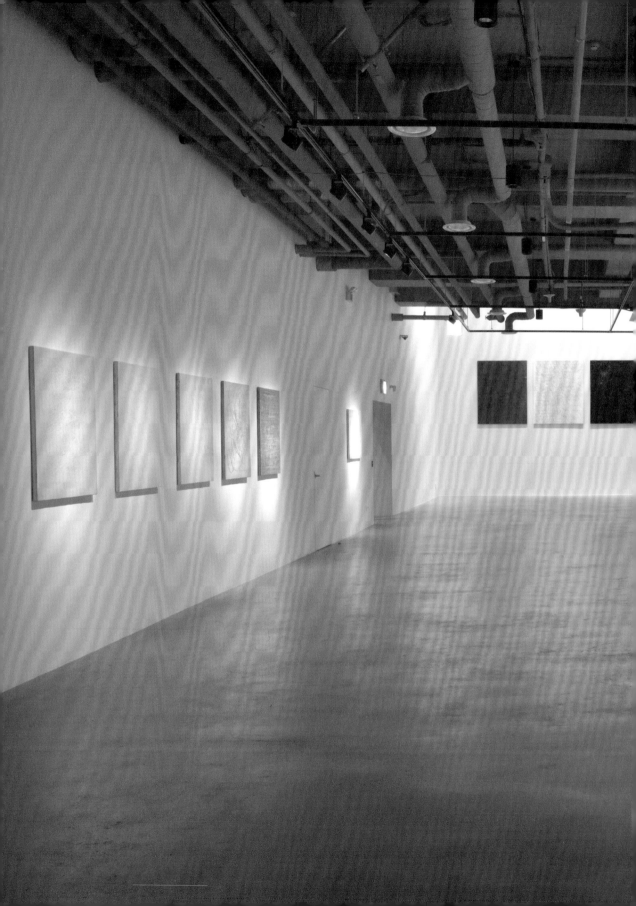

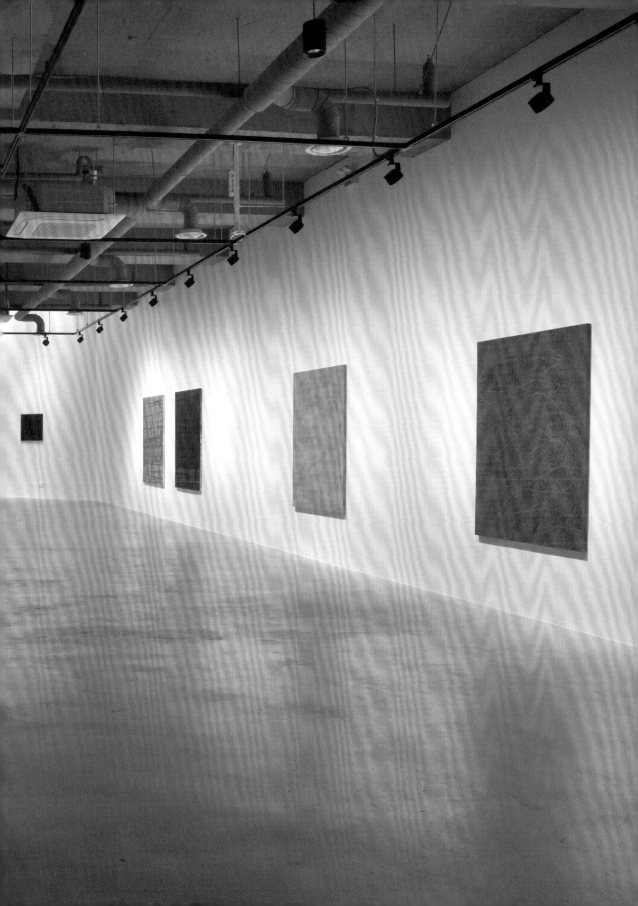

바람소리 그리고 흔적

변종필
(제주현대미술관장, 미술평론가)

화가의 작품세계에서 변화는 숙명인가?

화가는 자신의 예술세계에 대하여 끝없는 변화를 추구한다. 화가는 누구나 자신만의 스타일을 확립하기 원하지만, 특정 스타일에 고착되는 것을 거부하고 위험을 감수하고라도 작품의 변화를 추구하기도 한다. 그러나 그 변화가 자신의 작품세계를 확고히 하거나 위상을 정립하는 데 항상 도움이 되는 것은 아니다. 어떤 경우에는 그저 한 가지 틀에서 벗어나고 싶은, 혹은 벗어나야 한다는 강박관념에 사로잡혀 변화 요인을 설명하지 못하거나 무의미한 변화에 그치기도 한다. 그럼에도 불구하고 화가라면 누구나 언제든지 새로운 작품세계를 창출하기 위해서라면 지금까지의 자신을 과감히 벗어 던진다.

화가 강운은 구름을 그리는 작가로 알려져 있다. 20대부터 자신의 이름처럼 구름 세계를 화폭에 담아왔다. 그러나 그는 구름으로 얻은 명성을 뒤로하고 새로운 변화를 스스로 독촉했다. 그간의 작품세계를 돌아보면 자연이라는 커다란 주제 아래에 지속적인 변화를 꾀했음을 확인할 수 있다. '〈밤으로부터〉-〈순수형태〉-〈순수형태-순환〉-〈空 위에 空〉-〈공기와 꿈〉-〈물 위를 긋다〉'로 이어져 온 변화과정은 현실에 안주할 수 없는 작가적 태도에 따른 모습이다. 이번 전시에 선보인 작품 역시 마찬가지다. 외형적 변화만 보면 그간의 작품보다 훨씬 파격이 심하다. 그런데도 그의 작품은, 언제나 그랬듯, 단절보다는 맥락적으로 연결되어 있다. 이번 전시 작품 역시 표현의 형식과 재현의 대상이 다를 뿐, 그가 추구해온 작품세계의 주요 요소들은 고스란히 존속돼 있다.

1. 바람

이번 개인전에 출품된 강운의 작품에서는 '철책', '철조망', '상처'와 같은 자극적인 단어가 눈에 띄지만, 사실상 핵심어는 '바람'이다. 작품의 모든 형상적 이미지는 바람과 연결되어 있다. 달리 표현하면 바람으로부터 모든 작품이 탄생한 셈이다.

바람은 그 자체를 그릴 수 없다. 단지 바람이 스치고 지나는 순간, 바람이 흔들고, 남긴 흔적만 확인할 수 있다. 바람은 어떤 것으로 가둘 수도 잡을 수도 없다. 그저 느낄 수 있을 뿐이다. 그 느낌은 시간, 장소, 상황마다 다르다. 오전과 오후, 어제와 오늘이 다르고, 작년과 올해가 다르고, 계절마다 다르다. 남쪽의 바람과 북쪽의 바람도 다르다. 바람은 성격 또한 다양하다. 간지럽거나 부드럽기도 하지만, 매섭고, 거칠기도 하다.

바슐라르는 바람의 여러 단계는 각각 고유한 심리를 갖는다고 했다. "바람은 흥분하기도 하고 소침해지기도 한다. 바람은 울기도 하고 하소연하기도 한다. 바람은 격정에서 낙담으로 옮겨가기도 한다. 좌충우돌이고 무용한 바람의 성격 자체가 기진한 우울과는 매우 다른, 안절부절한 우울에 대한 이미지를 줄 수도 있다."[1]

1 가스통 바슐라르 지음(정영란 옮김), 『공기와 꿈』, 이학사, 2000, pp.408-409

바람은 형태로 존재하지 않지만, 바람 속에는 누군가의 삶이 있다. 기억, 회한, 슬픔, 기쁨이 있고, 아픔, 사랑, 상처, 꿈이 있다. 바람은 강운에게 언어로, 음률로 말을 걸어온다. 이 같은 바람소리에 강운은 귀 기울이고, 몸과 마음으로 바람을 느끼고 다양한 표현형식으로 바람을 그렸다. 구름, 꽃잎, 물을 통해서 그린 것이 대표적이다. 그런데 이번에는 철조망을 통한 바람이다.

2. 철조망

철조망 연작은 구체적 경험에 기인한다. GOP에서 복무했던 시절의 경험을 바람처럼 표출했다. 개념적으로 훈련되기보다는 자신의 감정에 지극히 충실한 작가적 성향을 유감없이 발휘했다. 그리고 작가 개인의 경험은 DMZ라는 특수한 공간으로 인해 함께 공유할 수 있는 감정으로 확산된다. 바람이 기억에 잠긴 감정을 깨워 흔들고, 마음에 맺힌 응어리를 풀어내어 급기야 그의 손끝(붓끝)을 통해 분출하듯 화면에 다양한 흔적을 남겼다. "10여 년간의 작업이 힘들었던 고통의 시간을 잊고 싶어서 그린 것이었다면, 철조망 연작은 덮어 두려던 상처의 감정들을 꺼내 들어 들여다보는 과정이라 할 수 있다."라는 작가의 말처럼 내면에 침잠된 감정이 폭풍처럼 휘몰아쳐 캔버스에 남긴 흔적은 살아내기 위해 묻어두어야 했던 지난 상처의 감정들이다. 이는 〈흔적〉, 〈철책단상〉이란 제목의 연작들에서 확인된다. 작품을 보면 감정에 몰입된 상태의 숨김없는 표현이랄까. 철책에서 느낀 감정이 여과 없이 전달된다. 철책을 마주하며 느낀 여러 감정들을 거짓 없이 순수하게 표현했기에 화려한 미사여구 없이도 작품제작 당시 작가의 감정이 관람자에게 고스란히 전이된다. 검은 바탕, 붉은 바탕, 푸른 바탕은 시간의 흐름일 수도 작가 감정의 상태나 자연의 변화일 수도 있다. 또한 날카로움이 그대로 감지되는 철조망이나, 끝이 무뎌져 부드럽게 느껴지는 철조망은 작가에게 준 상처의 발원이며 동시에 결과일 수 있다.

철조망을 화면 가득 채운 구성방식은 구름으로 캔버스 전체를 채웠던 방식과 다르지 않다. 표현하고 싶은 대상을 그리고, 붙이는 방법을 통해 최대한 온몸으로 느낄 수 있도록 하는 강운만의 조형방식은 이번 시리즈에서도 그 효과를 드러낸다. 작품을 마주할 때마다 화면 가득 채워진 작가의 감정을 함께 공감할 수 있도록 한 구성의 효과이다.

인간은 누구나 상처를 안고 산다. 타인에게 일일이 고백하지 않을 뿐, 그러나 품고 있는 상처가 모두 치유되는 것은 아니다. 치유되었다고 믿고 싶을 뿐. 강운 작가 역시 내면에 침잠된 상처가 있다. 하지만, 그 상처는 꼭 타인에 의한 것은 아니다. 세상을 겪으며, 스스로 떨쳐내지 못하고, 하나둘씩 마음에 남겨둔 상처들이다.

철조망을 모티브로 한 유화작품들은 살기 위해 버티고, 견뎌야 했던 숱한 감정들을 철조망 형상으로 표현하고, 그 형상을 닦아내고, 지우기를 반복하는 과정을 거친다. 이때 마음을 할퀴고, 찌르던 예리한 철조망은 어느새 부

드러운 선이 되어, 마음에 생채기들을 어루만지듯 감싸준다.

3. 바람소리 그리고 흔적

바람은 자신의 트라우마를 달래주던 하늘을 그릴 때부터, 지금의 철조망 연작까지 그가 방황하고, 아플 때마다 위로하고 보듬어주었다. 이때 바람이 내는 소리는 그때그때의 상황에 맞는 자연의 목소리이며, 음성이다. 어떤 바람소리는 핏빛처럼 섬뜩하고, 어떤 바람소리는 꿈처럼 달콤하다. 또 어떤 바람소리는 꽃망울을 터트리며 피어오르듯 아름답다. 이렇듯 바람소리를 느낄 수 있는 철조망 연작은 마치 작품에 담긴 의미가 비극적인 색채를 띠면서도 치명적 아름다움을 발산하는 이중성을 지녔다.

이러한 이중성은 추상성의 바람과 바람이 스치고 지나간 흔적을 볼 수 있는 철조망의 관계, 보이는 것과 보이지 않는 것의 관계, 물질적이며 비물질적인 관계처럼 손으로 직접 만지고, 확인할 수 있는 실체와 손끝으로 느끼고 짐작할 수 있는 비실체의 관계성을 대변하기도 한다. 이 점에서 강운의 바람소리 그리고 흔적은 인간이 맺는 관계의 상징이기도 하다. 철조망 끝에 매달려온 바람소리를 통해서 바람을 인식하고, 철조망 사이사이에 남겨진 흔적을 통해서 바람(자연)을 인식한다. 여기에 추상적 상징성이 강한 바람이 구상적 감정이 묻어나는 철조망을 통과하면서 울리는 공명은 누군가의 아픈 기억을 위로하고, 지치고 힘들어 흩어지기 쉬운 영혼을 달래는 역할까지 기대하게 한다.

작가는 누구나 변화의 시기를 겪는다. 강운은 광활한 들판 위 불어오는 바람 앞에 자신을 홀로 세워 이 변화를 마주하고 있다. 그리곤 내면세계에 대한 철저한 자기 들여다보기를 시도하며, 온전한 자기의 길을 정리하려 애쓴다. 그 과정에서 치유하지 못한 채 묻어두었던 상처가 돋아나는 아픔을 겪기도 하지만, 더는 감추지 않고 당당하게 내세워 부딪치기를 주저하지 않는다. 무엇보다 무의식 속에 잠재한 그 상처의 감정들이 아이러니하게 지금의 자신을 지탱하게 하는 요인으로 작용함을 깨달으며 작가적 성숙을 겪는다. 때로는 '내 안에 있는 나 자신도 모르는 것, 이것이 나를 비로소 만든다'-폴 발레리,〈Monsieur Teste〉-는 말처럼 자신 안에 자신도 잊고 지냈던 기억들로 인해 비로소 자신을 찾기도 한다. 특히 마음속에 응어리져 있는 형언하기 힘든 무언의 압박, 초조, 불안의 감정을 자신을 발전시키는 계기로 삼는다. 이 모든 과정은 화가의 숨김없는 솔직함, 진솔한 감정표현을 담은 자유로운 몸짓에서 비롯된다.

예술의 힘은 작가의 순수함과 자유로움을 통해 강해진다. 강운은 바람을 통해 마주한 모든 감정을 화폭 위에 순수하게 옮겨 놓았다. 그리고 미술계의 편견이나 시장논리, 작가적 위상이나 현실 안주로부터 벗어나는 자유로움을 택했다. 이러한 모습이야말로 '강운다움'이며, 그것을 마주할 수 있는 것만으로 이번 전시는 충분한 의미를 지닌다.

The Sound of Wind and Traces

Byun Jong-Pil

(Art critic, Director of Jeju Museum of Contemporary Art)

Is change inevitable in art worlds of artists? For anyone that is a artist, there is a never ending pursuit of change in their art. While they desire to establish their own style, they reject being stuck in a certain style but willingly take risks by seeking change in their works. Yet, change doesn't always help artists establish their own art style. Some artists are so obsessed with breaking out of a box that they end up making pointless changes, the reasons for which they can't even explain. Nevertheless, artists are always willing to bravely shed their old selves in order to create new art worlds.

Kang Un is known as an artist who draws clouds. He has lived up to his name, Un(雲) meaning clouds, painting the world of clouds since his twenties. Despite the reputation he has already gained through his works depicting clouds, he has pushed himself to effect change in his art. Looking back on his previous works, one finds that he has kept seeking change under the larger theme of nature. Kang strived to avoid complacency facing the status quo through the series of *From Night, Pure Form, Pure Form: Circulation, Emptiness beyond Emptiness, Air and Dream, and Strokes on the Water.* Likewise, one may notice some changes in the works introduced in this exhibition. In terms of external features, their style stands out the most. However, they are linked with the previous art works in a contextual way rather than a fragmented one, like Kang's artworks have always been. While the forms of expression and the objects of representation have been changed, the major elements of Kang's art style remain in the works of this exhibition.

1. Wind

Among the descriptions of Kang's artworks presented in this solo exhibition, some sharp words such as "wire fence" and "wounds" may grab one's eyes, yet wind is the true keyword. All the formal images of Kang's artworks are related to the wind. In other words, the wind is the birthplace of his works. The wind itself can't be portrayed. One can only find the traces it leaves behind the moment it blows, passes by, or stirs up something. Nothing can trap or seize the wind. The wind can only be felt. How it is felt varies depending on the time, place, and situation. It is felt differently in the morning, in the afternoon; it differs between yesterday, today, last year, this year, or different seasons. The feelings of winds in the south and north are different. Finally, the wind can also be said to have various personalities. Sometimes it tickles, feels gentle, but sometimes it can be fierce and violent.

Gaston Bachelard once remarked that each phase of the wind has its own psychology. "The wind stirs itself up and becomes discouraged. It howls and groans. It goes from violence to distress. The very nature of the curtailed and useless gusts can give an image of anxious melancholy that is very different from oppressed melancholy." [1]

Even if the wind is intangible, not having any forms of existence, it carries people's lives within itself: their memories,

1 Gaston Bachelard, *Air and Dreams: An Essay on the Imagination of Movement* (Dallas : Dallas Institute Publications, 1988), p. 245

their remorse, their sadness, their happiness, their hurt, their love, their wounds, and their dream. The wind speaks to the artist Kang in its own language of sounds. While listening to the sound of the wind and feeling the wind through his body and soul, Kang has drawn the wind in various ways. The ways he chose to represent the wind were clouds, petals, and water. In this exhibition, he chose to portray the wind through the forms of wire fences.

2. Wire Fence

The Wire Fence series is based on Kang's experience of having served in a General Outpost (GOP) in the Korean Demilitarized Zone (DMZ). It's almost like his past experiences and the feelings they evoke are expressed through the wind. The style of the artist, who is more faithful to his inner feelings than any external concept of discipline, is fully reflected in the series. The unique space of DMZ allows him to effectively communicate emotionally with the viewers. The wind shakes up feelings that were submerged in his memory, breaks down his emotional blocks, and leaves visible traces on the canvas, as if it gushes out through his fingertips—the tips of his brushes.

Kang remarks, "while my artworks during the last decade were drawn in order to forget painful times, the current series of wire fences is more akin to the process of undressing an infected wound and taking a closer look at it—just like the wounded feelings I had attempted to cover up." The traces left on the canvas by feelings churning deep inside him represent the wounds of the past that he had to bury during the course of his life. In the Traces and A Thought on Wire Fences series, the artist delves into his feelings and candidly express them. What he felt looking up at the fences while standing guard is fully carried over through the series. His pure expression of what he felt in the past allows the series to fully communicate the feelings he had while creating it to the viewers. Backgrounds of black, red, and blue colors signify the passage of time, the emotional states of the artist, or changes in nature. Some wire fences look sharp while others that lose their edges feel soft. Perhaps they are the source and the outcome of his wounds.

He fills canvases with the image of wire fences. This kind of composition is what he also used in his previous paintings, which were filled with clouds. Kang's style of leaving no empty room on a canvas by painting on or attaching various materials to it maximizes the work's emotional impact on the viewer. In the Wire Fence series, his style continues to prove effective in allowing viewers to sympathize with the artist's feelings.

Everyone has his or her own wounds that they can't reveal to others. Not all wounds can be healed, even if people want to believe otherwise. Kang also has wounds buried within himself. Not all of his wounds are caused by others. Some wounds left within himself are self-inflicted and didn't heal throughout the course of his life.

Kang has transformed the feelings he had to endure throughout his life into the wire fences we see in the series. While working on the oil paintings of wire fences, he goes through a process of drawing and erasing the forms of wire over and over. All the while, the wire fence that used to scratch and pierce his mind gradually turns into soft lines that gently soothe his wounds.

3. The Sound of Wind and Traces

The wind has always comforted and embraced Kang, whenever he wanders and feels hurt, from the time when he drew the paintings of sky that helped heal his trauma to the time when he created *the Wire Fence* series. The sound of the wind is like the voice of nature that differs from situations. It sounds sometimes frightening like a dark blood, sometimes sweet like a dream, and sometimes beautiful like a blooming flower bud. *The Wire Fence* series through which one may feel such a multifaceted sound of wind has a double meaning: It has a color of tragedy but exudes a deadly beauty.

This duality is also shown in the relationships between the abstractness of an intangible wind and the physicality of a wire fence that makes traces of the wind visible, between the seen and the unseen, between the physical and the non-physical, and between the substance that is identifiable by touch of hands and the non-substance that is only inferable through sense of fingertips. In this sense, *the Sound of Wind and Traces* series symbolizes the relationship between people. The wind is perceived through its sound that hangs at the end of a wire fence and the traces it leaves as sweeping through the wire. As passing by, the wind that is highly symbolic and abstract in nature resonates with the wire that figuratively represents feelings. The resonation between the wind and the wire comforts one's grief-stricken memory and the exhausted souls that are almost about to disperse.

Every artist goes through a period of change. In his time of change, the artist Kang Un lets himself stand alone against the wind blowing over the vast plains. He carves his way to the more complete self through a thorough self-reflection on his inner world. Sometimes he suffers when the unhealed past wounds break through the mind. Nonetheless, he never hesitates to reveal his wounds and face with them. His artistic self becomes more mature when he comes to realize the ironic fact that his wounded feelings in unconsciousness sustain himself and make who he is now. Sometimes, the forgotten memories help one to finally find oneself, like the phrase from Paul Valéry's *Monsieur Teste* suggests: "It is something unknown I carry within myself that finally makes me." For Kang, the lump of indescribable feelings such as pressure, nervousness and anxiety are what develops himself. The whole process of change is based on the artist's unbound expression that purely carries over the feelings.

The pure and unrestrained expression of an artist makes the power of art stronger. The artist Kang Un has translated all the feelings he experienced through the wind onto the canvas, without any disguise. He has chosen not to be bound by any biased judgement in the art scene and the logic of art market; and he has also strived to avoid complacency at the status quo, not sticking to his current status in the art scene. This is the way the artist Kang Un is. This exhibition is worth a visit where one may find oneself resonating deep with the real self of Kang Un.

밤으로부터(From Night), Oil on canvas, 162×130.3cm, 2019

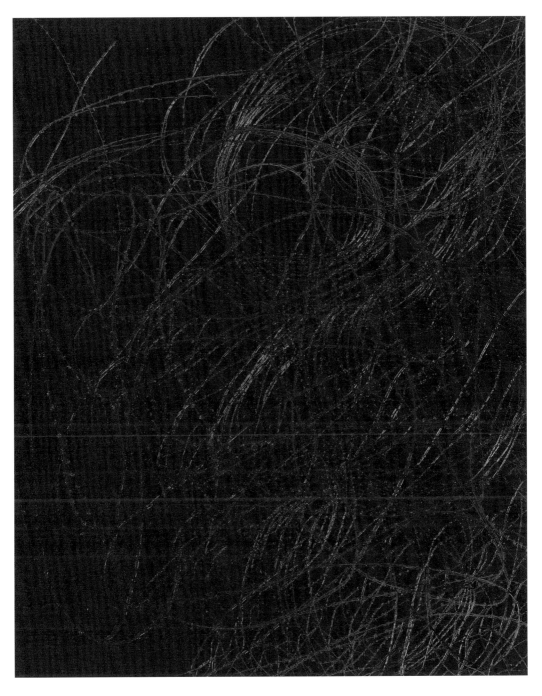

철책 단상(A Thought on Wire Fences), Oil on canvas, 162×130.3cm, 2019

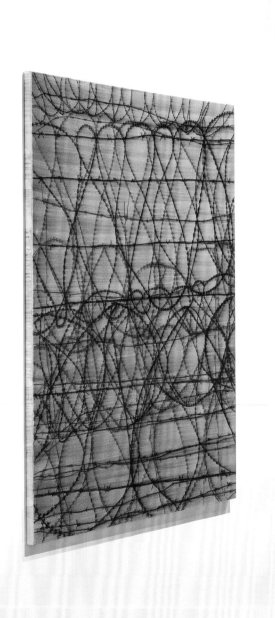
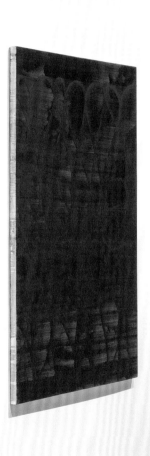

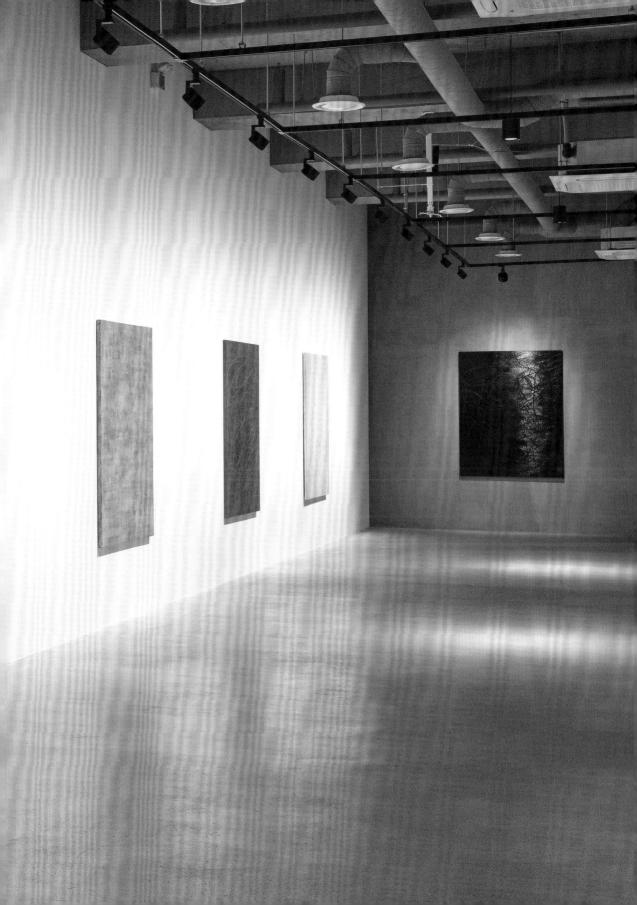

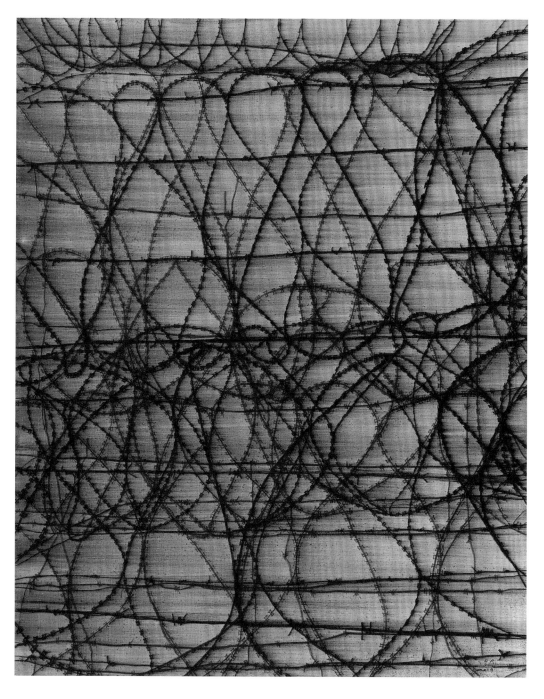

바람소리(The Sound of Wind), Conte, oil on canvas, 162×130.3cm, 2019

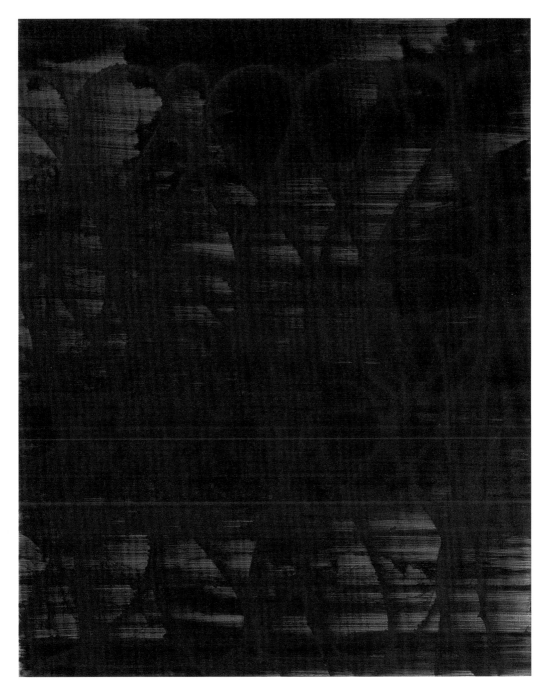

바람소리(The Sound of Wind), Conte, oil on canvas, 162×130.3cm, 2019

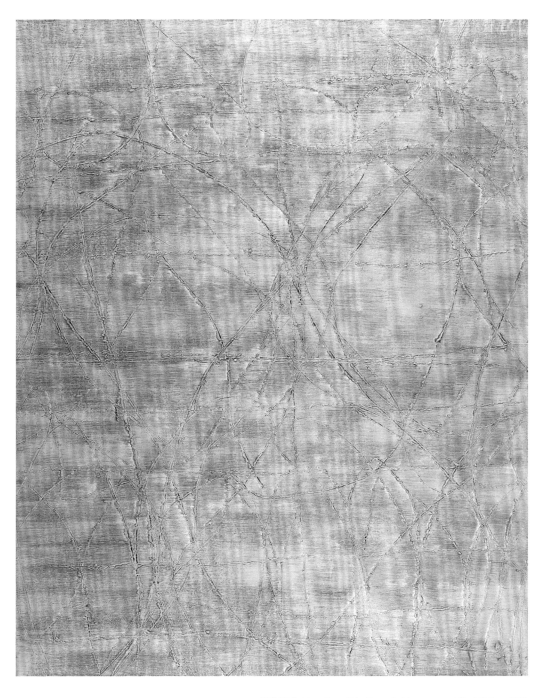

철책 단상(A Thought on Wire Fences), Oil on canvas, 162×130.3cm, 2019

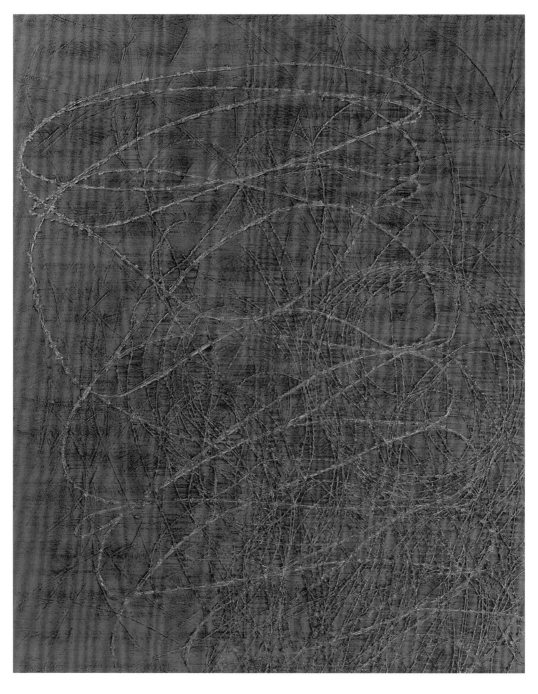

철책 단상(A Thought on Wire Fences), Oil on canvas, 162×130.3cm, 2019

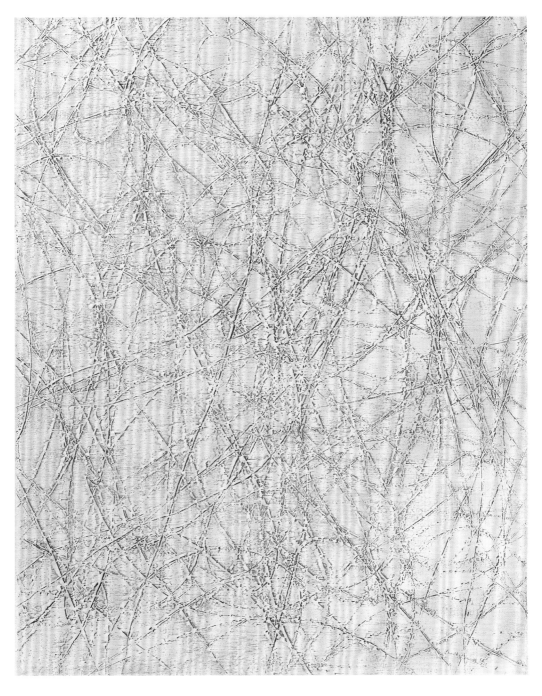

철책 단상(A Thought on Wire Fences), Oil on canvas, 162×130.3cm, 2019

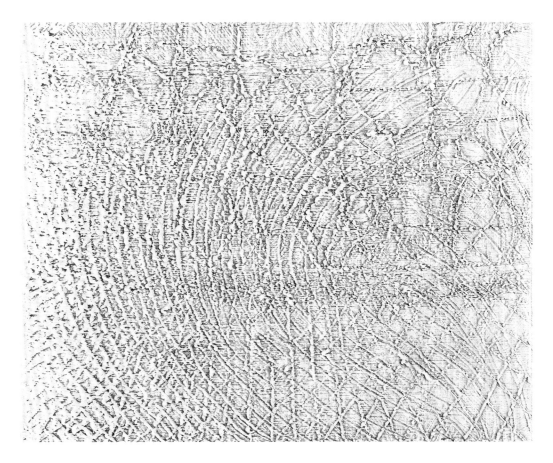

철책 단상(A Thought on Wire Fences), Oil on canvas, 72.7×90.9cm, 2019

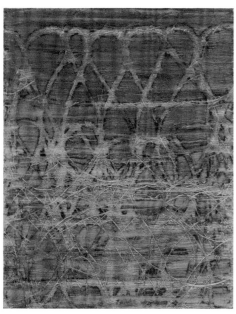
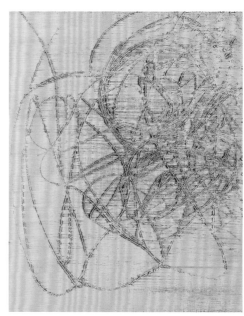

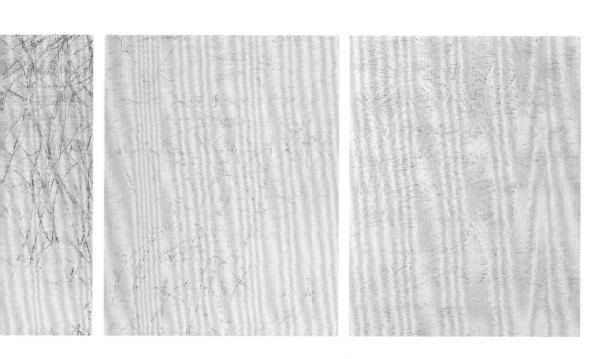

철책 단상(A Thought on Wire Fences), Oil on canvas, 90.9×72.7cm, 2019
철책 단상(A Thought on Wire Fences), Oil on canvas, 90.9×72.7cm, 2019
흔적(Traces), Oil on canvas, 90.9×72.7cm, 2019
흔적(Traces), Oil on canvas, 90.9×72.7cm, 2019
흔적(Traces), Oil on canvas, 90.9×72.7cm, 2019

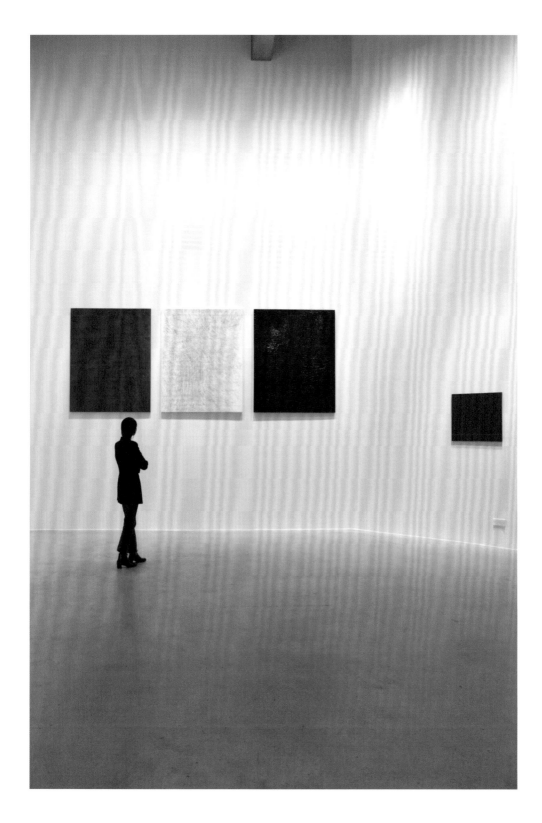

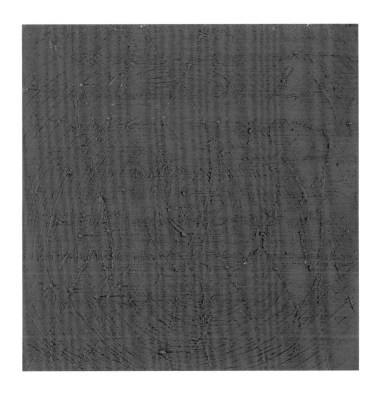

철책 단상(A Thought on Wire Fences), Oil on canvas, 65×65cm, 2019

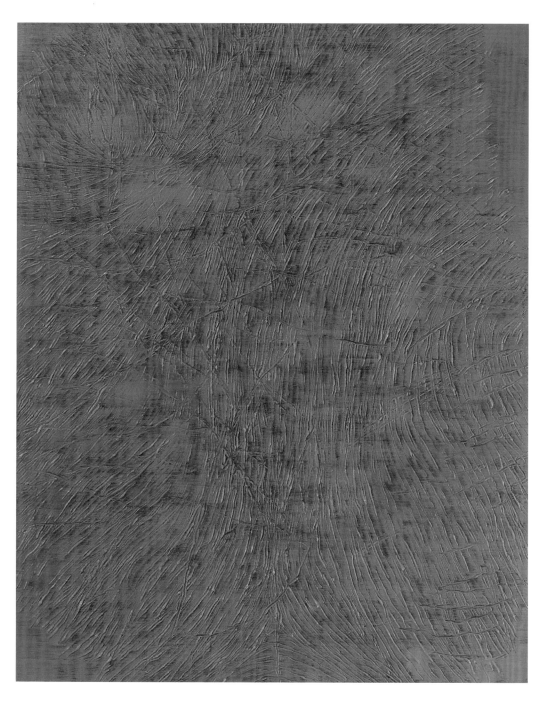

몸의 시간(Vestiges of Time), Oil on canvas, 162×130.3cm, 2019

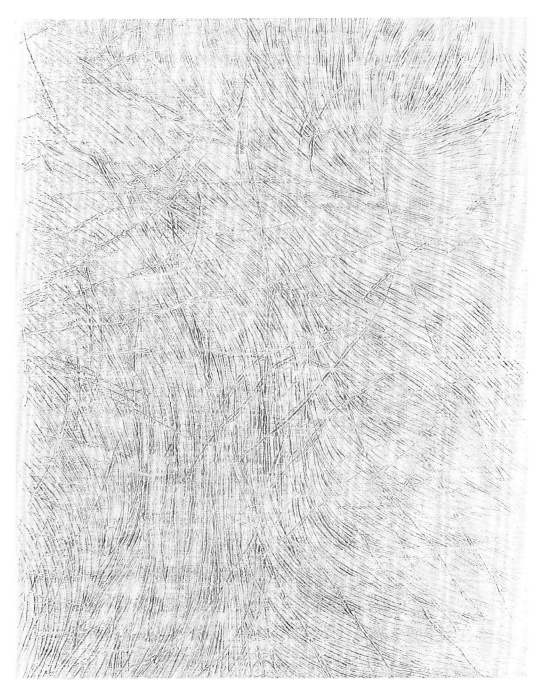

몸의 시간(Vestiges of Time), Oil on canvas, 162×130.3cm, 2019

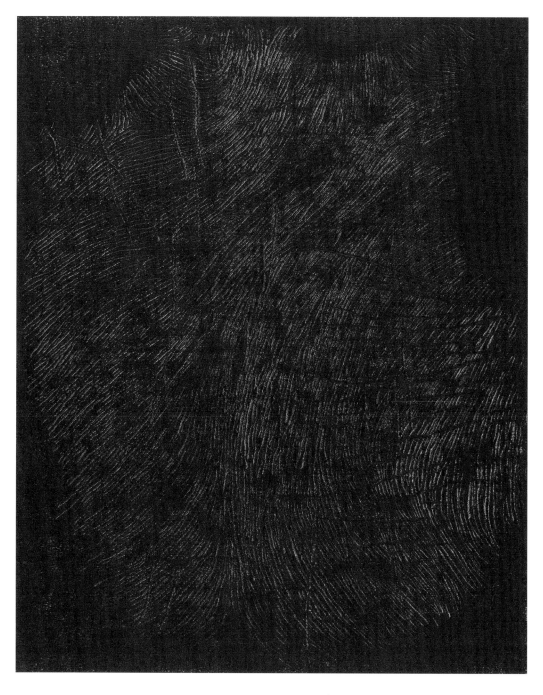

몸의 시간(Vestiges of Time), Oil on canvas, 162×130.3cm, 2019

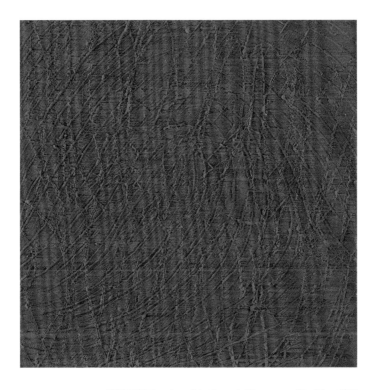

철책 단상(A Thought on Wire Fences), Oil on canvas, 65×65cm, 2019

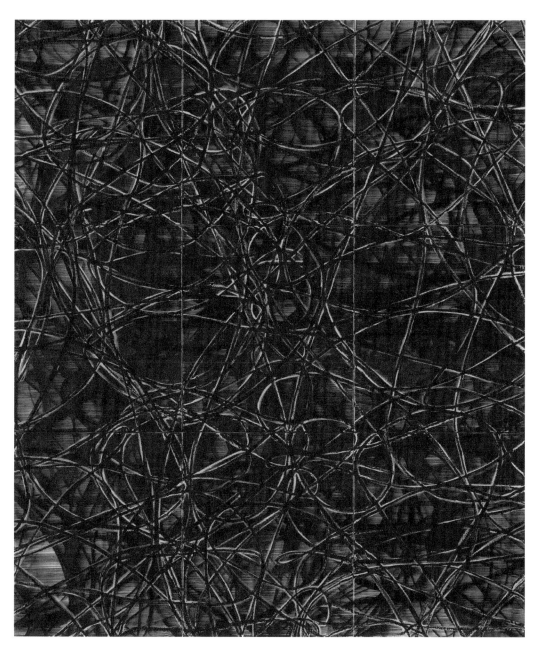

기억된 미래(Memories into the Future), Oil on canvas, 159.5×136.5cm, 2019

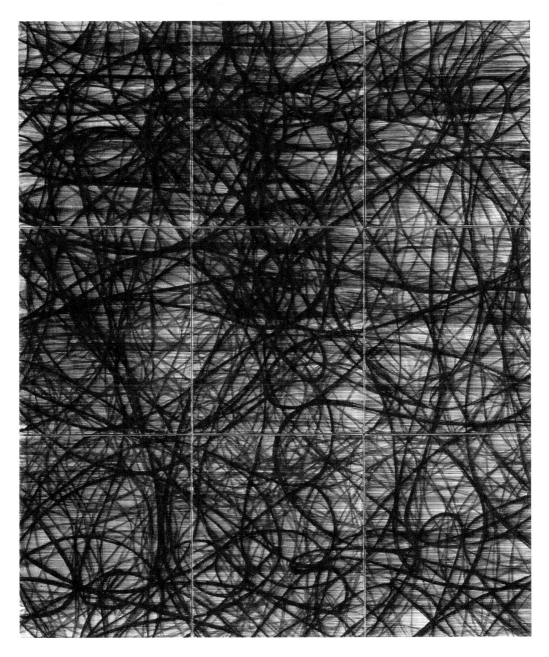

기억된 미래(Memories into the Future), Oil on canvas, 159.5×136.5cm, 2019

바람소리 그리고 흔적

강운
(작가)

이번 전시타이틀 〈바람소리 그리고 흔적〉은 삶의 과정에서 만나는 크고 작은 상처를 어루만지듯 예리했던 철조망이 부드러운 선이 되고 자유로운 예술이 되길 소망하며 그린 작품이다. 또한 누구나 안고 살아가는 상처에 대해 나는 어떤 느낌과 태도를 갖고 있을까. 그리고 그 감정의 기억을 어떻게 치유하고 살아가는가에 대한 개인적 답변이다.

나이를 먹으면서 알게 된 것 중의 하나는 삶이 두 가지 기억으로 이뤄져 있다는 것. 기쁨인가 싶으면 슬픔이고, 불행인가 싶으면 결국은 행운이고, 우연인가 했지만 필연이었던 일들이 많다는 것이었다. 나이를 더 먹으면서 알게 된 것은 아무리 몸은 늙어도 마음은 늙지 않아 여전히 사랑하고 싶고, 모든 시작에 끝이 있기 마련이니 매 순간 최선을 다하고 싶다는 것. 인생은 산 너머 산이지만 아무도 대신 넘어가 줄 수 없으니 열심히 밥 먹고 힘내서 잘 넘어야 된다는 것이다. 누구나 상처를 안고 살아간다. 상처 때문에 힘들다고 말하곤 했는데 상처 자체와 상처에 대한 나의 태도는 다를 수 있다는 걸 새삼 깨닫는다. 비슷한 상처를 겪으면서 어떤 이는 허물어지고 누군가는 더 단단해지는 이유가 거기에 있는 듯하다. 결코 상처받지 않겠다고 이를 악무는 것이 아니라 어떤 상처가 찾아와도 거기서 견디고, 다시 일어서겠다는 생각, 그것이 나의 태도였고 나였다는 것을 알게 된다.

요즘 나의 작업은 추상과 재현의 경계를 넘나든다. 10여 년 간의 작업이 힘들었던 고통의 시간을 잊고 싶어서 그린 것 이었다면 이번 연작은 덮어 두려던 상처의 감정들을 꺼내어 들여다보는 과정이라고 할 수 있다. 캔버스에 작은 상처들을 그리고, 긁어내고, 지우기를 반복하면서 덮어 두려던 감정들이 낱낱이 드러나는 불편함과 마주하게 된다. 겹겹이 지우고 덮는 과정은 모든 치유의 과정과 묘하게 닮았다. 그리고 결국 남는 것은 상처의 흔적 같은 추상의 화면과 색이었다. 이렇듯 DMZ의 철조망으로 시작한 화면은 〈바람소리〉, 〈상처〉, 〈흔적〉 작업으로 연쇄 작용을 일으켰고 나의 시선은 자연스레 마음의 상처와 흔적에서 몸의 그것으로 옮겨갔다. 그리고 〈몸의 시간〉과 〈기억된 미래〉로 진행되었다.

바슐라르(Bacherlard)는 기억이 구체적인 기간을 기록하지 않는 이상한 것이라고 강조하였다. 또한 우리는 기억 속 시간의 파편들을 다시 체험할 수 없으며 단지 불명확한 추상적 시간의 한 연장선에서 그것을 생각할 수 있을 뿐이라 말했다. 나에게 선과 색은 복잡하고 규정할 수 없는 기억과도 같다. 어느 선 하나 한곳에 머무르지 않으며 어느 색 하나 한 이미지에 한정되지 않고 다른 이미지로 그리고 또 다른 이미지로 이동한다. 선과 색은 캔버스 밖의 세계로 나의 기억과 감정을 상기시키는 매개가 된다. 나는 불편하고 대면하기 어려웠던 심리적 상처를 소환하여 작업을 통해 치유되기를 바랐다. 그리고 〈바람소리 그리고 흔적〉을 위해 움직인 나의 몸과 시간은 어쩌면 시간 밖에서 우리가 만날 수 있기를 기다리고 있던 혼을 달래는 제(祭)의 시간이었는지도 모른다는 생각이 들었다.

The Sound of Wind and Traces

Kang Un
(Artist)

Under the title, *The Sound of Wind and Traces* is an exhibition presents series of works that embody my hope of nur-turing our wounds we face in life, just as sharp wire fences could turn into soft lines—free and liberated in the realm of art. These paintings were born through a contemplation on what kind of feelings and attitudes I have about the wounds that everyone lives with, and how I can heal the emotional memories throughout the course of life.

As years passed, I realized that one's life consists of two types of memories. When something presents itself as happiness, later it turns out to be sadness, or something that is unfortunate later manifests as a fortune. At times, an event that seemed like an accident ends up feeling like destiny–and these opposing forces are inextricably intertwined in our lives. Another truth I found was that even though bodies age, our hearts stay young and we wish to keep falling in love. As there is an end to every beginning, we wish to make the most of every moment. There's a long and winding road ahead that life has laid out, but since nobody can walk it for us, we should eat well and overcome the mountains and mountains of obstacles. Everybody lives with their own wounds. While I used to express my struggles from my own wounds, I have found that one's attitude towards wounds and wounds themselves are separate entities. Perhaps this is the reason why some people give way to pain while others become stronger, although they suffer from similar things. I had always tried to endure any wounds and get back on my feet, rather than bracing myself against any pos-sible pain while gritting my teeth. A realization came to me: my attitude towards pain shapes who I am.

My recent work transgresses the border between abstraction and representation. While my body of work during the last decade were drawn in order to forget painful experiences, the current series is more akin to the process of undressing an infected wound and taking a closer look at it—as if to face the painful feelings I had attempted to cover up. While repeating the process of drawing, scraping off and erasing small wounds on canvases, I felt the uneasiness that arises when every secret feeling that had once been suppressed is revealed. The process of erasing and covering up canvases curiously resembles the process of healing. In the end, what was left on the canvases were abstractions, like traces of wounds as what began with drawing the wire fences of the DMZ sparked a series of works; *The Sound of Wind, Scar, and Traces*. Along the way, my thematic attention naturally extended from wounds of mind to wounds of body, which leaded to the works of *Vestiges of Time* as well as *Memories into the Future*.

Gaston Bachelard remarked that memory is a strange thing, as it does not record a concrete duration. We're unable to relive those fragments of time in our memories, and instead we can only reimagine a past occurrence as an indistinct extension of an abstract sense of time. Lines and colors are like memories that are intricate and unable to define. No single line stays the same space, and no single color is bound by the same image, but they move on to another series of images. They function as the medium that connects the world outside the canvas, allowing me to recall my memories and feelings. I hoped that any bruises in my mind, which had been uncomfortable for me to face, could be healed through the acts of drawing. And it crossed to my mind that working on *The Sound of Wind and Traces*, striving mentally and physically, perhaps I was performing a ritual to soothe spirits who might be waiting for us outside of time.

강 운 (姜 雲)

1966 강진 출생, 대한민국
1990 전남대학교 예술대학 미술학과 졸업

개인전

2019 〈상처, 치유〉, 신세계 갤러리, 부산
2017 〈Sky, Touch the air〉, 프랑수아 리비넥 갤러리, 파리, 프랑스
2016 〈Play : Pray〉, 사비나미술관, 서울
2012 〈물, 공기, 그리고 꿈〉, 포스코 미술관, 서울
2005 〈순수형태 - 소만(小滿)〉, 광주시립미술관 금남로 분관, 광주
1998 〈내일의 작가전〉, 성곡미술관, 서울
 외 18회

단체전

2019 〈DMZ〉, 문화역 서울 284 , 서울
 〈JIIAF 2019 일상의 예술〉, 지리산아트팜 미술관, 하동
 Google (HTC) Taipei 기획전 〈Into the Light〉, HTC corporation, 타이페이, 대만
2018 〈ONE INSPIRATION〉,주일한국대사관 한국문화원, 시로타화랑, 도쿄, 일본
 〈제철비경〉, 포스코미술관, 서울
2017 〈Time + Time, Korea Contemporary Art Now〉 , Da xiang art space, 타이중, 대만
 〈Ailleurs est ici〉, École des filles, 브루타뉴, 프랑스
2016 〈2016 Contemporary Art 20 of China and Korea〉, Ucity Art Museum of GAFA, 광저우, 중국
2015 〈남도미술 200년〉, 부산시립미술관, 부산
2014 〈Heritage, Legacy and Light〉, UNESO Headquarters, 파리, 프랑스
 〈Korean Beautiy-Two Kinds of Nature〉, 국립현대미술관, 서울
2013 〈All About Korea〉, White Box Gallery, 뮌헨, 독일
 〈Wind as Motif in Art〉, 이화여자 대학교, 서울
2012 제9회 광주비엔날레, 〈라운드테이블〉, 광주
2011 〈쉼, 展〉, 경기도 미술관, 안산
2009 제4회 프라하 비엔날레 〈회화의 확장〉, 프라하, 체코
2005 〈침묵의 우아함〉, 모리미술관, 일본

2003	〈진경 - 그 새로운 제안〉, 국립현대미술관, 과천
2000	제3회 광주비엔날레 〈人 + 間전〉, 광주
	〈보이지 않는 경계-변모하는 아시아미술〉, 니가타 시립미술관, 우츠노미아미술관, 일본

레지던시
1999-2000	제2기 쌈지 스튜디오
2001-2003	제2기 광주시립미술관 팔각정 창작 스튜디오
2004-2005	제1기 광주시립미술관 양산동 창작 스튜디오

수상
1999	광주예술문화 신인상, 광주예총, 광주

작품 소장처
일본 모리미술관(일본), 일본 Roppongi T-Cube(일본), 국립현대미술관(한국), 서울시립미술관(한국), 아트선재센터(한국), 성곡미술관(한국), 경기도미술관(한국), 대구미술관(한국), 포스코미술관(한국), 광주시립미술관(한국), 제주도립미술관(한국), 수원시립아이파크미술관(한국), 포항시립미술관(한국), 삼성의료원(한국), 안양 베네스트 골프장(한국) 외 다수

주소
이메일 : kangun1203@hanmail.net
홈페이지 : http://kangun.creatorlink.net/INTRO

CV

| 1966 | Born in Gangjin, South Korea |
| 1990 | Graduated from Dept. of Fine Arts, Chonnam National University, B.A |

Solo Exhibition

2019	'Wound, Healing ', Shinsegae gallery, Busan, Korea
2017	Sky, Touch the air ', Francoise Livinec, Paris, France
2016	'Play : Pray ', Museum of Savina, Seoul, Korea
2012	'Water, Air and Dream ', Museum of Posco, Seoul, Korea
2005	'Pureness Form–Soman ', Gumnamno Branch Gallery, Gwangju Museum of Art, Gwangju, Korea
1998	'Artist of Tomorrow ', Sungkok Art Museum, Seoul, Korea
	Other 18 times

Group Exhibition

2019	'DMZ ', Culture station Seoul284, Seoul, Korea
	'JIIAF 2019', JirisanArt Farm Museum, Hadong
	Google (HTC) Taipei 'Into the Light', HTC corporation, Taipei, Taiwan
2018	'ONE INSPIRATION ', Korean Culture Center Japan, Shirota gallery, Tokyo, Japan
	'The Mysterious Landscape of Steel ', POSCO Art museum, Seoul, Korea
2017	'Time + Time ' Korea Contemporary Art Now, Da Xiang art space, Taichung, Taiwan
	'Ailleurs est ici ', École des filles, Bretagne, France
2016	'2016 Contemporary Art 20 of China and Korea ', Ucity Art Museum of GAFA, Guangzhou, China
2015	'200 Years of the namdo Art ', Busan Museum of Art, Busan, Korea
2014	'Heritage, Legacy and Light ', UNESO Headquarters, Paris, France
	'Korean Beautiy –Two Kinds of Nature ', National Museum of Modern and Contemporary Art, Seoul, Korea
2013	'All About Korea ', White Box Gallery, Munich, Germany
	'Wind as Motif in Art ', Ewha Womans University Museum, Seoul, Korea
2012	'Round Table' ,The 9th Gwangju Biennale Gwangju, Korea
2011	'Rest ', Gyeonggi Museum of Modern Art, Ansan, Korea
2009	'Expanded Paintings ', The 4th Prague Biennale, Prague, Czech Republic
2005	'The Elegance of Silence ', Mori Art Museum, Tokyo, Japan

| 2003 | 'Real Landscape - Its New Proposal ', National Museum of Modern Arts, Gwacheon, Korea |
| 2000 | 'Men + Space ' ,The 3rd Gwangju Biennale, Gwangju, Korea |

Residency Program

1999-2000	The 2nd Ssamzie Studio
2001-2003	The 2nd Gwangju Museum of Art Studio
2004-2006	The 1st Gwangju Museum of Art Yangsandong Studio

Awards

| 1999 | New Artist Prize of Gwangju Art & Culture by Gwangju Art Association, Gwangju |

Selected Colletions

Mori Art Museum (Japan) / Rop¬pongi T-Cube (Japan) / National Museum of Modern and Contemporary Art (Korea) / Seoul Mu¬seum of Art (Korea) / Art Sonje Center (Korea) / Sungkok Art Museum (Korea)/ Gyeonggi Museum of Mod¬ern Art(Korea) / Posco Art Museum (Korea) / Daegu Art Museum(Korea) / Gwangju Museum of Art(Korea) / Jeju Museum of Art (Korea) / Suwon I-Park Museum of Art(Korea) / Pohang Museum of Steel Art (Korea) / Samsung Medical Center(Korea) / Anyang Benest Golf Club (Korea)

Address

E-mail : kangun1203@hanmail.net

Website : http://kangun.creatorlink.net/

바람소리 그리고 흔적
아트스페이스3 #4

2019년 12월 4일 초판 1쇄 발행

지은이 아트스페이스3
펴낸이 조동욱
기 획 아트스페이스3
펴낸곳 헥사곤 Hexagon Publishing Co.
등 록 제 2018-000011호 (2010. 7. 13)
주 소 경기도 성남시 분당구 성남대로 51, 270
전 화 010-7216-0058 | 010-3245-0008
팩 스 0303-3444-0089
이 메 일 joy@hexagonbook.com
웹사이트 www.hexagonbook.com

ISBN 979-11-89688-23-3 04650
ISBN 979-11-89688-03-5 (세트)

이 도서의 국립중앙도서관 출판예정도서목록(CIP)은 서지정보유통지원시스템 홈페이지(http://seoji.nl.go.kr)와 국가자료종합목록 구축시스템(http://kolis-net.nl.go.kr)에서 이용하실 수 있습니다. (CIP제어번호 : CIP2019048377)